DOGGY STYLE

MILLY
BROWN

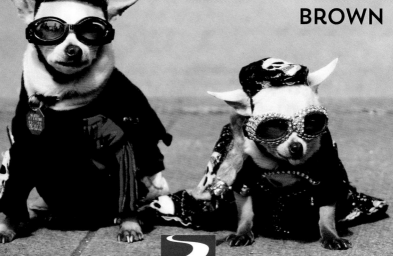

summersdale

DOGGY STYLE

Summersdale Publishers Ltd
46 West Street
Chichester
West Sussex
PO19 1RP
UK

www.summersdale.com

Printed and bound in China

ISBN: 978-1-84953-786-5

Substantial discounts on bulk quantities of Summersdale books are available to corporations, professional associations and other organisations. For details contact Nicky Douglas by telephone: +44 (0) 1243 756902, fax: +44 (0) 1243 786300 or email: nicky@summersdale.com.

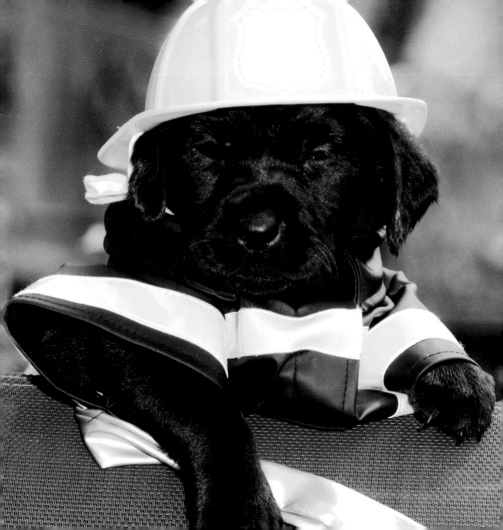

FIRE OFFICER MR
CHUBBLES, READY
FOR NAPPING. ER, I
MEAN, FOR DUTY.

I LIKE TO ENTERTAIN AN AIR OF MYSTERY *AND* FESTIVITY.

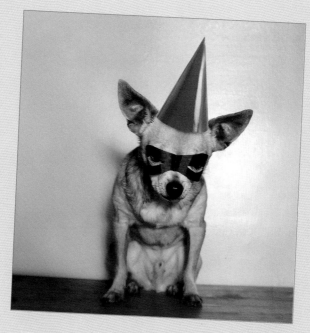

#SURPRISEPARTY

DOWN WITH THE CATIST REGIME!

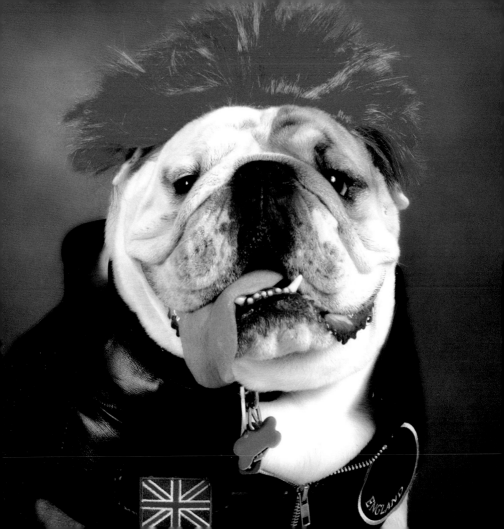

I LOVE PUMPKINS!

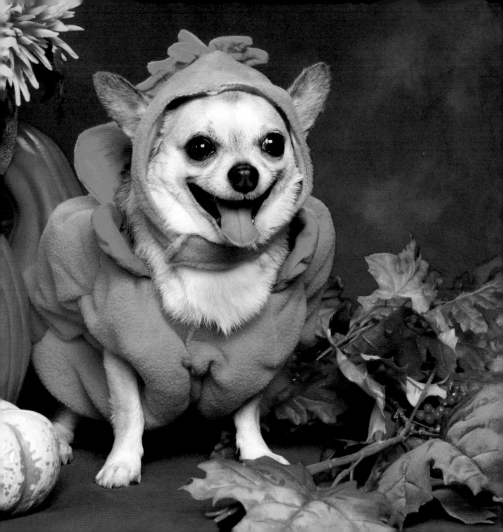

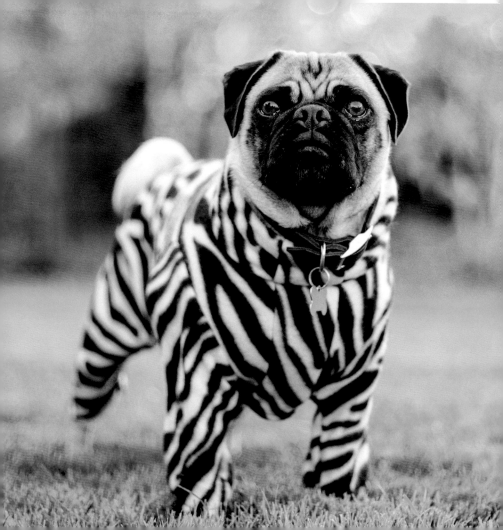

ZEBRAS ARE MY SPIRIT ANIMAL.

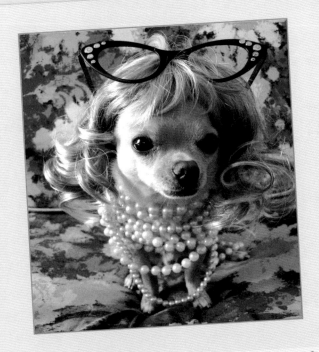

#DIFFERENT TYPE OF WAG

HOW DARE YOU CALL ME A GLAMOURPUSS! I'M A GLAMOURPUP, ACTUALLY!

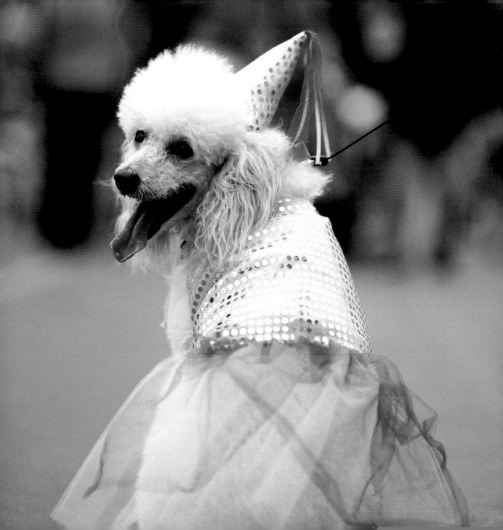

NO ONE TAKES YOU SERIOUSLY WHEN YOU'RE A MALE POODLE.

WHO ARE YOU CALLING A MUPPET?!

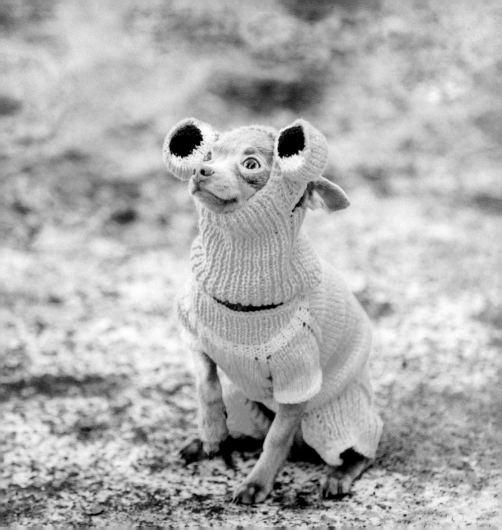

GRR ME HEARTIES!

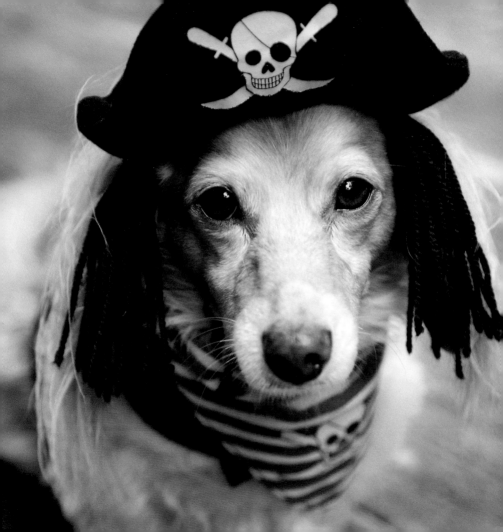

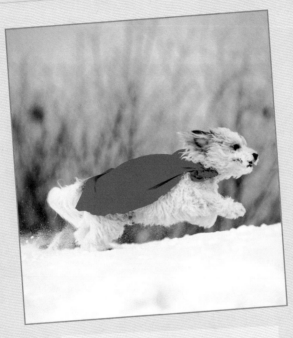

#UNDERDOG
#WONDERDOG

CITIZENS! MY NAME IS UNDERDOG AND I WILL SAVE YOUR NEIGHBOURHOOD FROM THE SCOURGE OF CATS, SQUIRRELS AND THE POSTMAN.

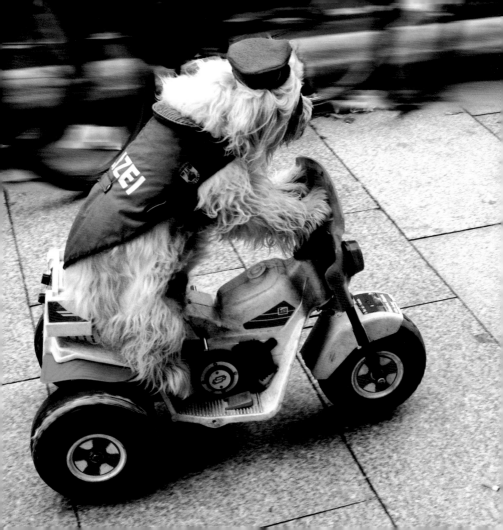

DON'T LET THOSE CAT BURGLARS GET AWAY!

I'M BAD TO
THE BONE.

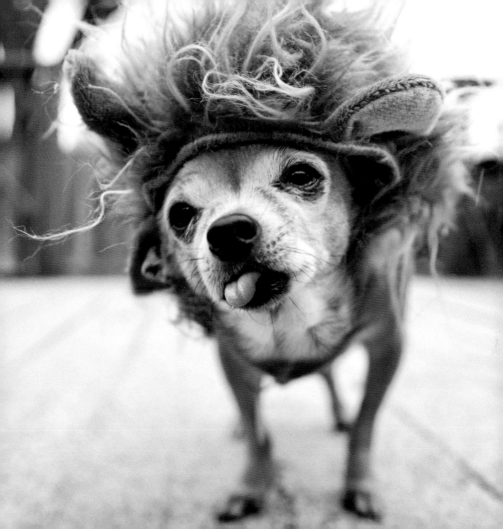

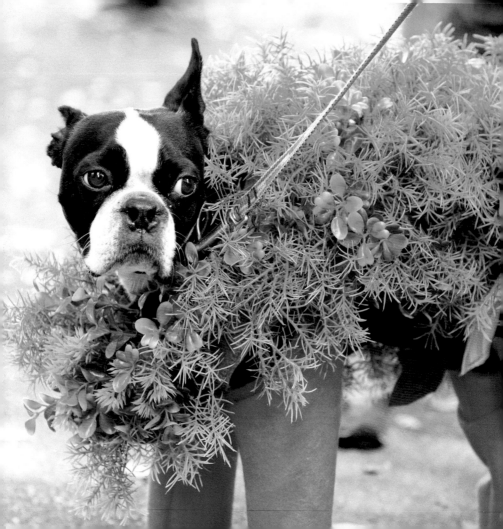

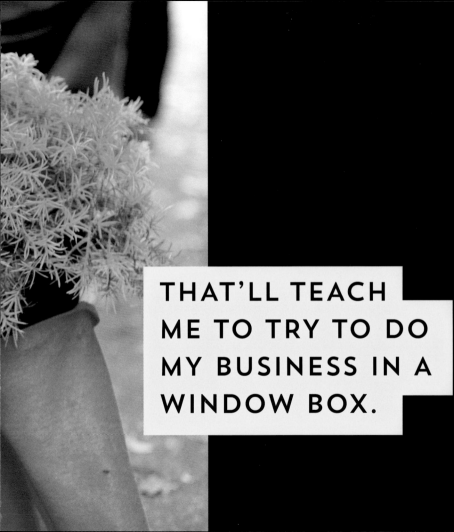

THAT'LL TEACH
ME TO TRY TO DO
MY BUSINESS IN A
WINDOW BOX.

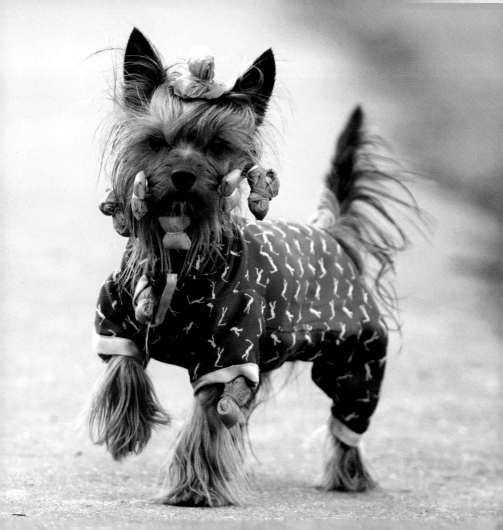

WHAT? WHERE'S THE WALLY? I CAN'T SEE HIM, GUYS!

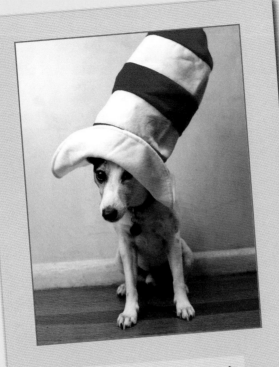

#DRPOOCH

CATS IN HATS ARE YESTERDAY'S NEWS!

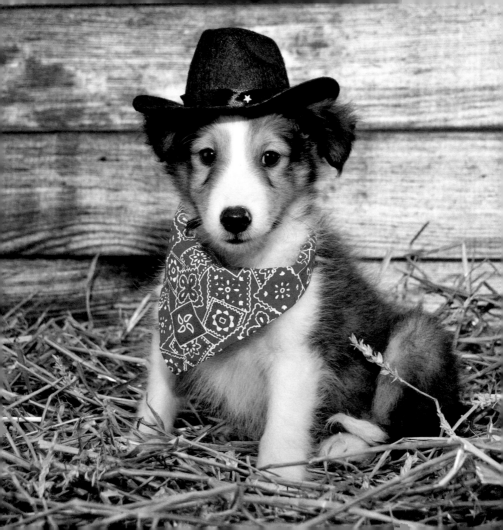

AWW, DAD, I'M NOT A SHEEPDOG, I'M A COWBOY!

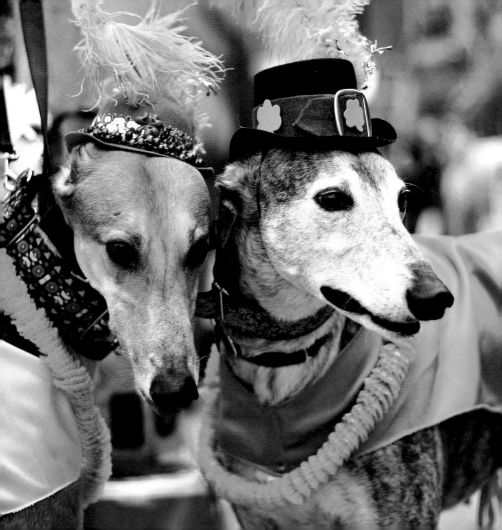

JENNY, ARE YOU *SURE* THIS IS WHAT THEY WEAR IN IRELAND? PEOPLE ARE STARING.

LOVE AND MARRIAGE – THEY GO TOGETHER LIKE WALKIES AND A SQUEAKY TOY.

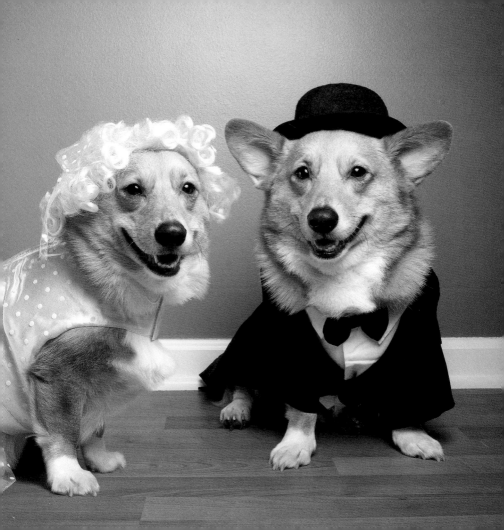

THEY SAY DRESS THE SIZE YOU WANT TO BE, NOT THE SIZE YOU ARE.

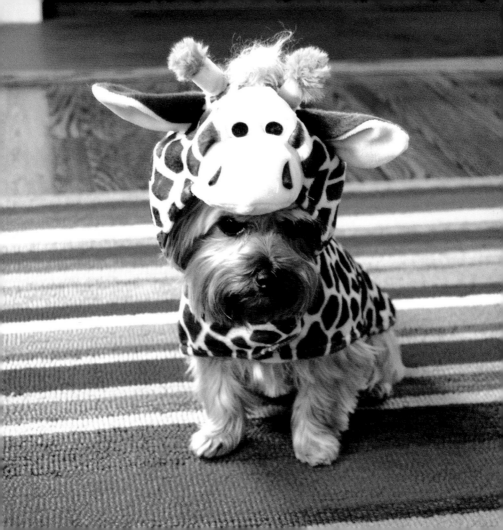

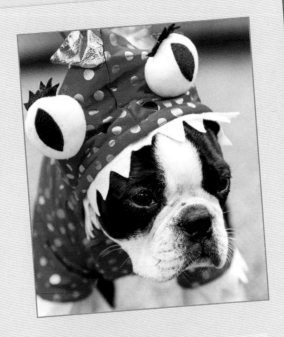

#1FTWEIRDO

I'M A GRR-OCIOUS MONSTER!

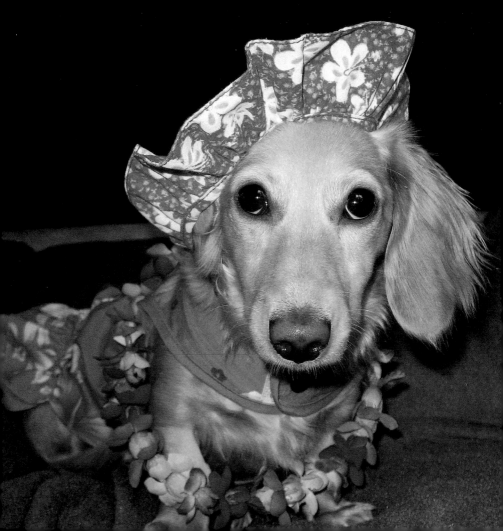

DO YOU THINK THIS IS A BIT MUCH TO WEAR ON THE AEROPLANE?

JUST BECAUSE YOU VISIT THE PARK TWICE A DAY, DOESN'T MEAN YOU SHOULDN'T DRESS UP FOR IT.

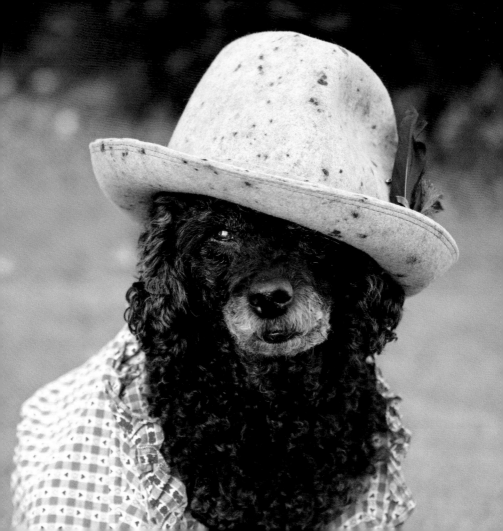

LET'S GO DOGGY-PADDLE-BOARDING!

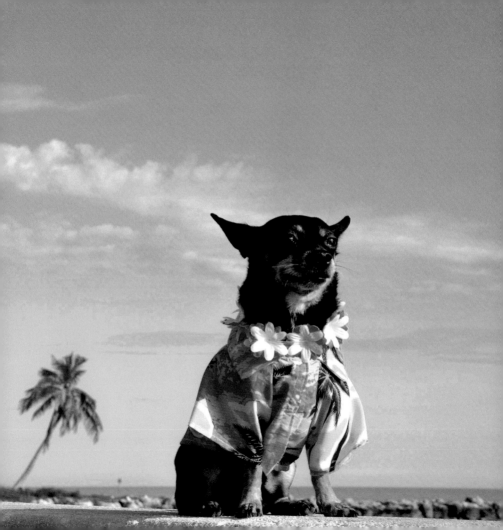

YOU LIKE MY HOUNDSTOOTH? THANKS. I HAVE A WHOLE MOUTHFUL OF THEM.

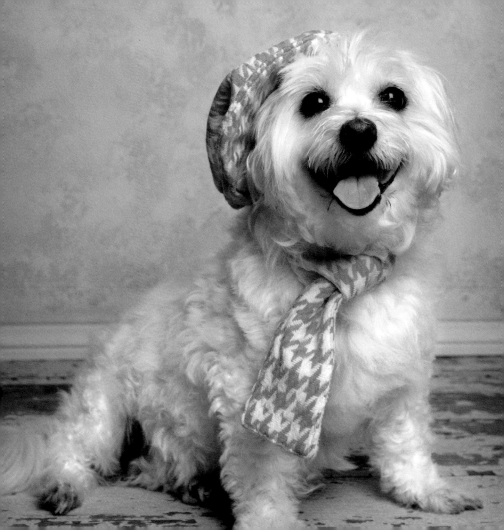

MY PERFECT FIRST DATE? A PICNIC IN THE PARK, FOLLOWED BY A WALK IN THE PARK, FOLLOWED BY A NAP IN THE PARK.

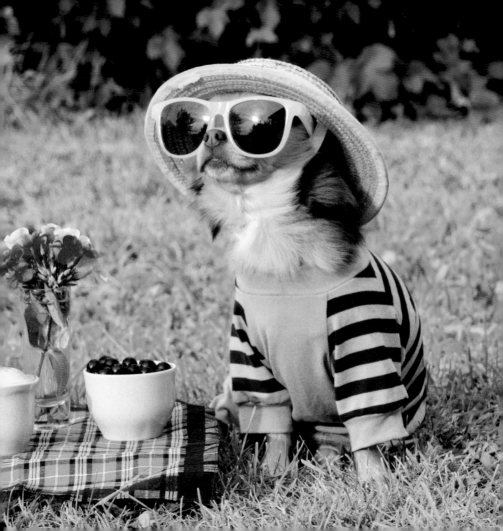

LITTLE GIRL, OF COURSE I'M THE REAL EASTER BUNNY.

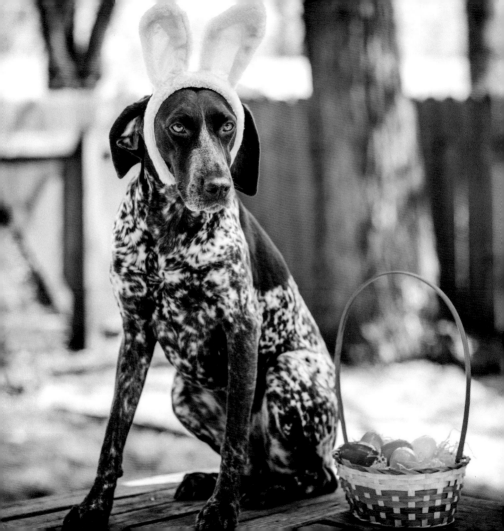

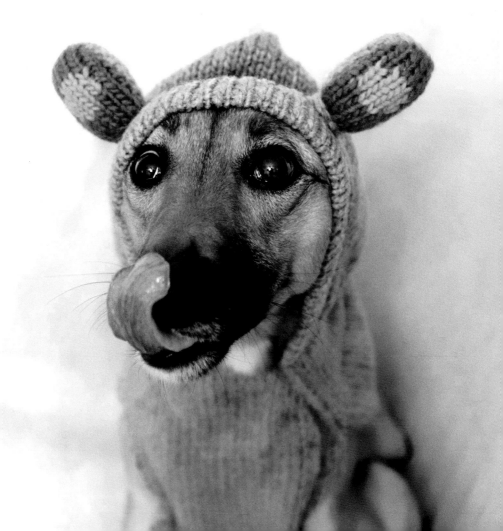

THIS IS MY FESTIVAL ONESIE, FOR COMFORT AND STYLE.

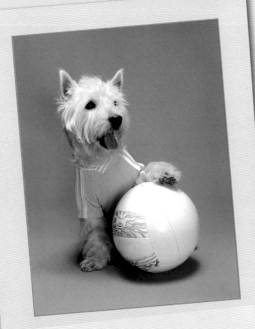

DROOLING NOT DRIBBLING

WELL, NATURALLY DAVID IS MY TRUE HERO, BUT VICTORIA IS THE INSPIRATION BEHIND MY NEW HAIRDO.

LOOK, NO ONE'S BABY PHOTOS ARE FLATTERING.

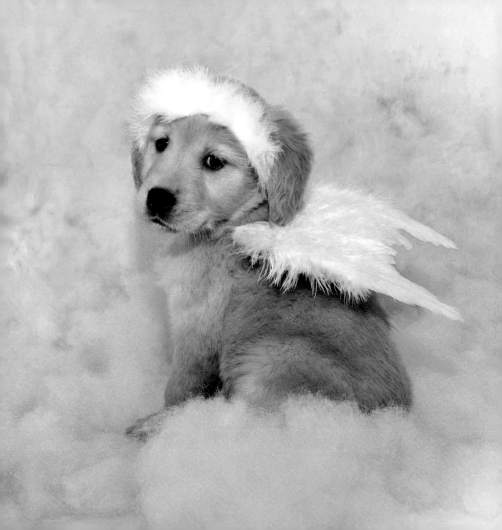

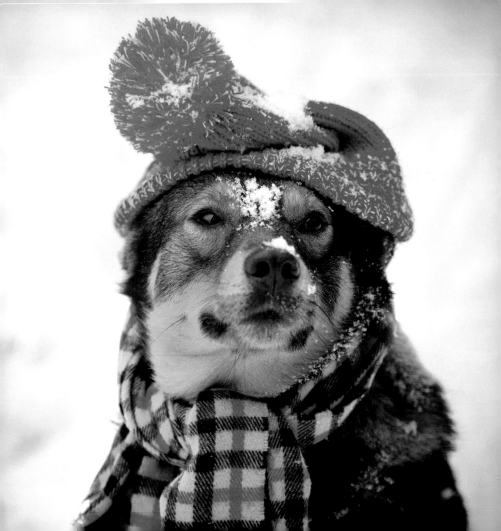

UGH, I'M MUCH MORE OF A SUMMER DOG.

I AM *LOVING* THESE NORDIC NOIR FASHION TRENDS.

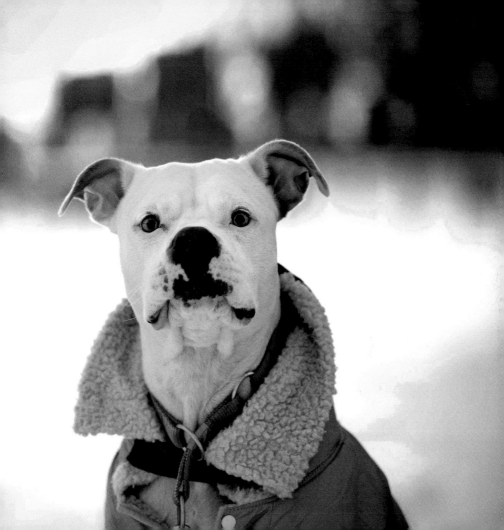

PHEW, THINK I GOT A PB OR TWO ON THAT RUN.

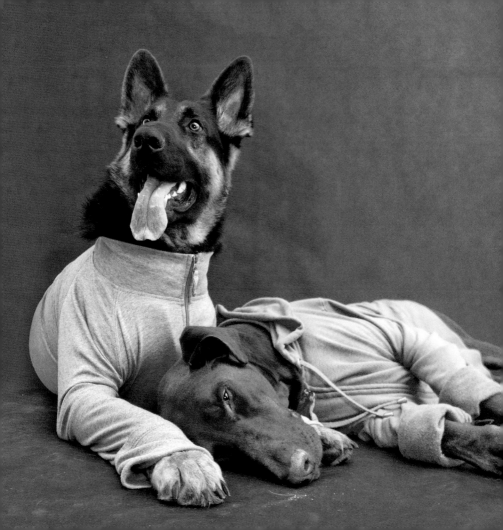

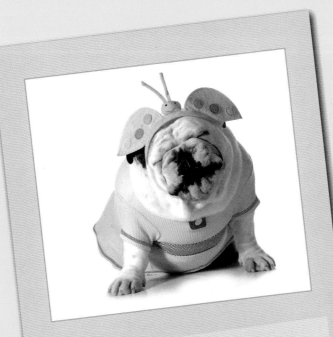

#UGLYBUGBALL

IT'S A BUG'S LIFE!

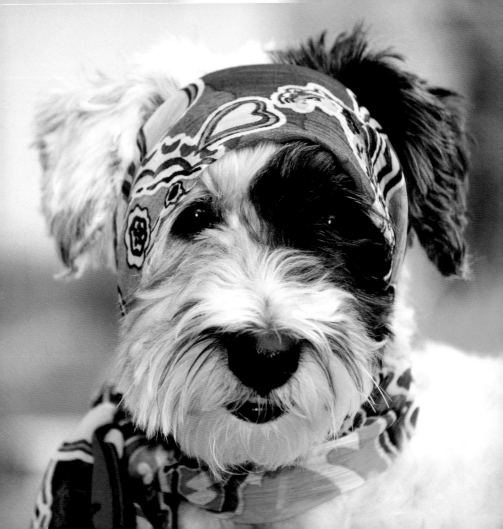

DAHLING, I ONLY EAT HAND-PREPARED ORGANIC DOG FOOD – IT'S GOOD FOR DETOXING.

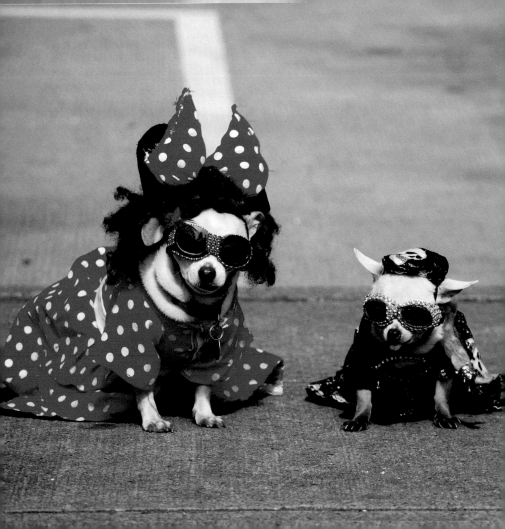

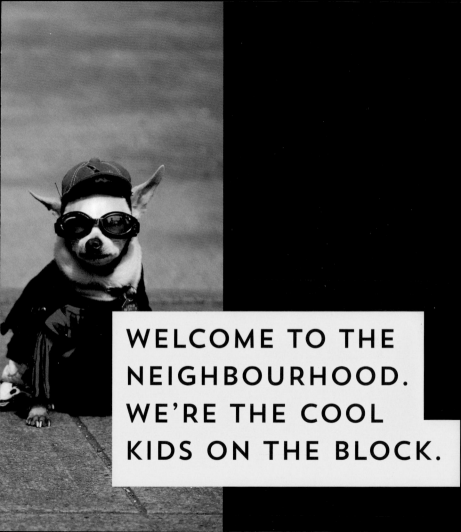

WELCOME TO THE NEIGHBOURHOOD. WE'RE THE COOL KIDS ON THE BLOCK.

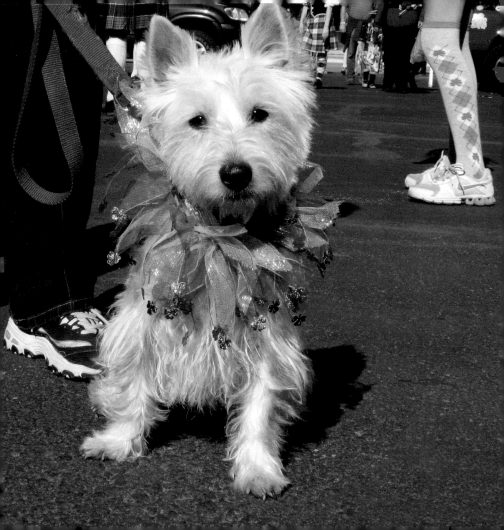

DO YOU THINK I'M OVERDRESSED? I WAS GOING FOR 'SMART CASUAL' BUT THE SPARKLES MIGHT BE TOO MUCH.

NO ONE WILL SEE
ME DIGGING UP
THE FLOWER BEDS
WITH MY CUNNING
DISGUISE.

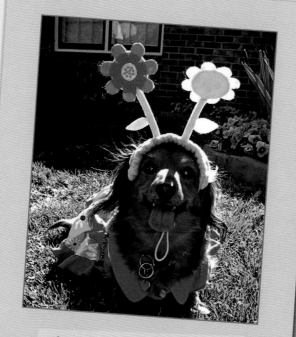

#SOCOVERT

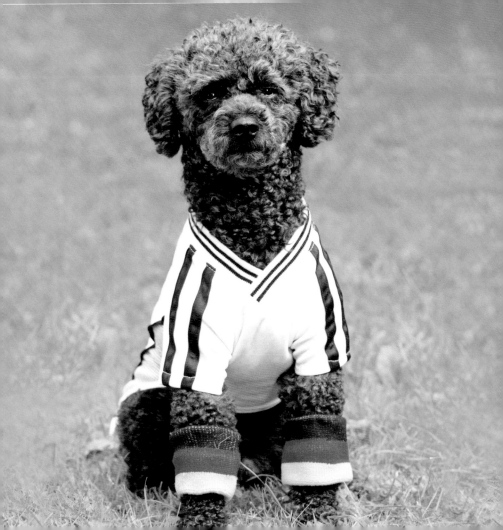

I'VE CREATED A NEW POSITION ON THE TEAM. IT'S CALLED 'FETCHER'.

THIS IS THE LAST TIME I'M LETTING MY MUM DRESS ME.

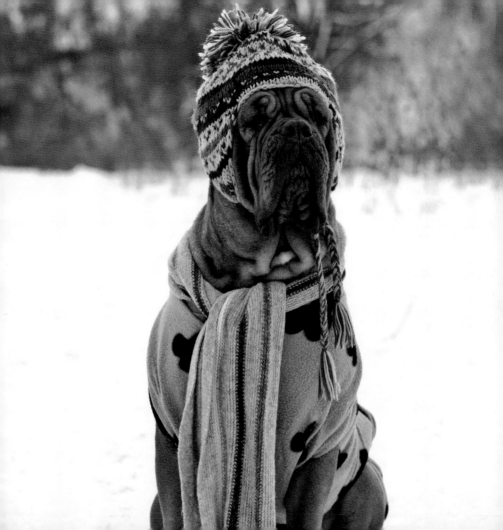

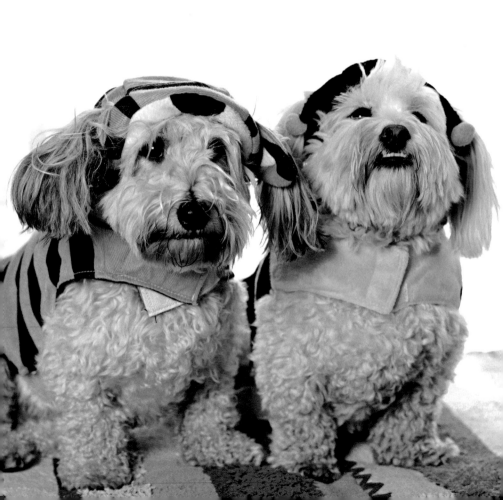

GOOD HEAVENS, JEFFREY, IS THAT REALLY YOUR 'PRETTY' SMILE?

THIS IS MY 'SERIOUS ACTOR' HEADSHOT.

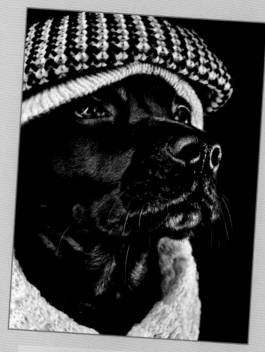

#HotDog

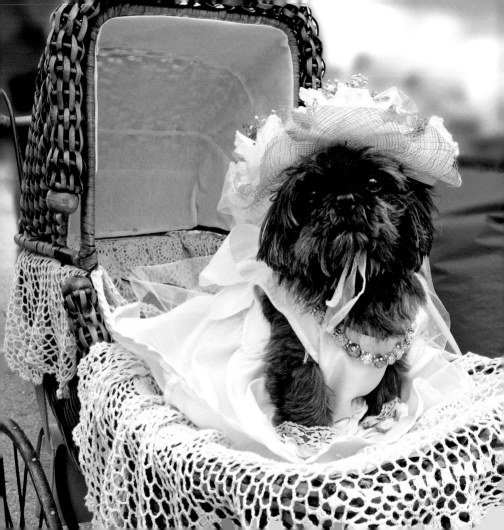

I HAVE TO UP MY GAME IF I'M GOING TO COMPETE WITH PRINCESS CHARLOTTE FOR CUTENESS.

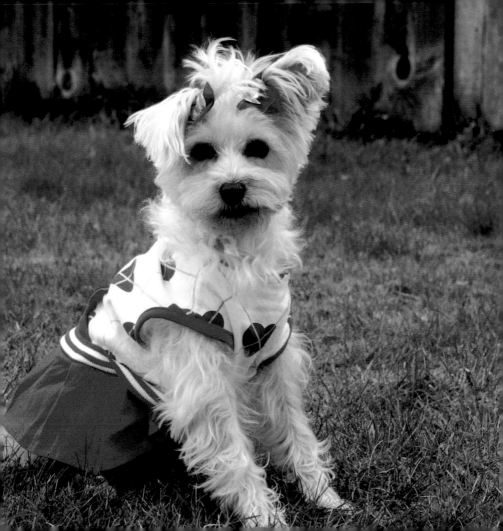

TWO, FOUR, SIX, EIGHT! CATS ARE WIMPS AND DOGS ARE GREAT!

FORGET DUCKFACE, WE'RE SERVING UP DOGFACE.

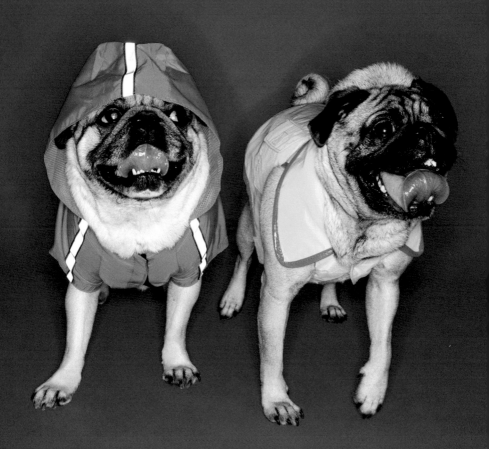

IT'S HARD TO BE A GOTH WHEN YOUR OWNER CHOOSES WHAT YOU WEAR.

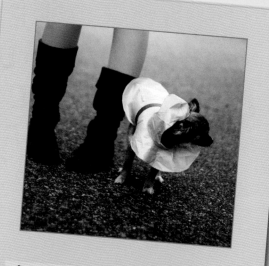

#NO I WONT SMILE
FOR THE CAMERA

PHOTO CREDITS

If you're interested in finding out more about our books,
find us on Facebook at **Summersdale Publishers**
and follow us on Twitter at **@Summersdale**.

www.summersdale.com